exit ambition

Jake Reber

Dostoyevsky Wannabe

exit ambition / jake reber

Exit Ambition
By Jake Reber
Dostoyevsky Wannabe, 2017
ISBN: 978-1543229257

Acknowledgements

Pieces from this collection have previously appeared in *West Wind Review*, *PANK*, and *Best American Experimental Writing 2015*.

for laur & clem

Contents

Action Painting: No Paint Just Action	1
re ^{de} _["pressed"]	13
(STAGE) exhibits/installations	27
KNIGHTMARE / PHANTASY	51
!mposs!ble performancez	71

ACTION PAINTING:

NO PAINT

JUST ACTION

The CAMERA HAS MOVED UP WITH HIM

The CAMERA WITH HIM
The CAMERA PULLS BACK SLOWLY as she descends

The CAMERA PULLS BACK WITH HER
The CAMERA HIGH

THE CAMERA WITH HIM
THE CAMERA PANS
THE CAMERA PANS

THE CAMERA PANS UP
THE CAMERA SLOWLY STARTS TO RECEDE

CLOSEUP: BOWL OF SOGGY CEREAL

THE CAMERA MOVES SLOWLY

EXTREME CLOSEUP
EXTREME CLOSEUP
EXTREME CLOSEUP

THE CAMERA WITHDRAWS AND GRADUALLY REVEALS
THE CAMERA PANS
THE CAMERA WITH HER

THE CAMERA IS VERY LOW
INTO THE CAMERA
TOWARDS THE CAMERA
FACING CAMERA
INTO THE SHOT PAST CAMERA
FACING AWAY FROM THE CAMERA

CLOSEUP

THE CAMERA FOLLOWING THEM
THE CAMERA NOW PRECEDING THEM
TOWARDS THE CAMERA
THE CAMERA FOLLOWING
THE CAMERA STOPS

FACING TOWARDS CAMERA

CLOSEUP
CLOSEUP

THE CAMERA PRECEDES HIM
THE CAMERA STOPS WITH HIM
TURNS TOWARDS THE CAMERA AGAIN
THE CAMERA AHEAD OF HIM AGAIN
THE CAMERA AHEAD OF THEM
THE CAMERA WITH THEM
THE CAMERA MOVES PAST HER TO CLOSE SHOT

THE CAMERA PANS
THE CAMERA PANS WITH THEM
THE CAMERA PRECEDES HIM
THE CAMERA FOLLOWING HIM
THE CAMERA IS SHOOTING OVER HIS SHOULDER

THE CAMERA PULLS BACK SLOWLY
THE CAMERA FOLLOWS
BACK TO CAMERA
THE CAMERA SLOWLY BEGINS TO MOVE IN AND DOWN, AND CENTERS
THE CAMERA MOVES TO A CLOSEUP

EXTREME CLOSEUP
EXTREME CLOSEUP
EXTREME CLOSEUP

THE CAMERA SHOOTING DOWN FROM HIGH ANGLE
THE CAMERA IS SHOOTING ABOVE
SCENE BETWEEN CAMERA
THE CAMERA SHOOTING FROM HIGH ANGLE TOWARDS HIM
THE CAMERA PANS WITH
THE CAMERA SHOOTING IN THROUGH THE OPEN
THE CAMERA PANNING WITH HIM

re/^{de}_["pressed"]

PERF. SCORES 1-10

1. A man is wearing a pink bodysuit. It covers his entire body, only leaving his head out. He tries to slip out, but can't find a zipper so he has to go out through the neck hole.

2. A woman is on stage. She is on stage with a young man - both are naked. She describes her first child's birth to him. The description is detailed down to the second. They are holding hands.

3. An image on the wall. It is painted on; It resembles a breast, but the nipple is still blurry. A man walks on stage and writes his mother's name in cursive across the painted wall. He appears to be crying.

4. There is a plastic bag full of kool-aid; it is on a table on the stage. The kool-aid is red. A woman walks on stage and punctures the bag with a scalpel. She tells the audience it's actually afterbirth - she's lying.

5. There is a woman on stage. She is wearing a stethoscope and nothing else. A man is laying on the table. He is wearing a hospital gown. They both hope their parents don't walk on stage and interrupt them.

6. There is a woman on stage. She is wearing a hospital gown. She does a slow chant. A doctor walks on stage and says the baby was delivered.

7. The men are on stage. They are covered in a mucus membrane. There is a projector showing THE MIRACLE OF LIFE - it is muted. They each take turns retelling their birth/rebirth (metaphorical or literal).

8. There is a mother on stage. She cuts a grapefruit in thirds with a razorblade. She then cuts the pieces again. She thinks about the instructions.

9. Nine children are on stage. They are all siblings. They are all exactly 9 months apart in age. They were all built in a factory.

10. There is a black hole on stage. It is labelled - memories & ghosts. Every actor on stage walks across and falls down into the hole, silently. After an hour, anyone who remains in the audience will see the resurrection of the bodies covered in white sheets. No one knows if they are dead or just breathing shallowly.

(STAGE)

exhibits/installations

The Tragic Death of Sylvia and Other Experiences of Internal Brain Explosions

There are no actresses on stage.

The room is empty, floorboards partially covered by a throw rug, the rest exposed; the window is open.

Curtain.

Deep Sea Divers and Whaleboats

The stage is open water. The audience might be on rafts, or wearing lifejackets. They will be wearing lifejackets and floating, wearing goggles.

In the openness floats a few boats, possibly real, possibly imaginary. Below the water are three divers. They stay under until they run out of air, then surface.

Curtain.

Sexual attraction in the wilderness

There are three women. They are all completely naked other than the mascot heads they are wearing. They are all different. One girl is a polar bear; another is a panther; the third is an old man. They sit with their legs crossed: two facing the audience, one facing the back wall. They are all smoking cigarettes.

A man walks on stage completely naked, other than a white polka-dotted tie. He lies down in between the women and whispers every thought that comes to his mind.

Curtain.

Camera and Knife
(slasher film)

There is a film crew: the camera operator, the focus puller, the clapperloader, the boom operator, the lighting technician, and a negative cutter smoking a cigarette.

The director walks on stage. He pulls a razorblade from his pocket and walks off the stage, out into the audience. The film begins rolling.

The director cuts a member of the audience. The negative cutter already called for an ambulance. The film crew records the entire trip to the hospital, and the procedure that follows.

Curtain.

Grandma's Diphthong

There is a twenty-three-year-old man wearing blue briefs. Beside him is a sixty-five-year-old woman. She is wearing a lacy bra and lacy panties. She begins to seductively remove her top. He starts talking about his first memory of his grandmother.

They trade bottoms. She leaves her bra on the stage.

Curtain.

Smoking after Sex

There is a woman on stage while the lights are out. She is smoking a cigarette: she is naked. She smokes the entire pack of cigarettes.

She leaves the lighter. She leaves the burnt-out butts. She leaves the empty pack.

Curtain.

Fur & Shit

The stage is dim. The man on stage is only wearing a fur coat, nothing else. He tries to suck on all of his fingers and toes at the same time. He then slips entirely inside of the fur coat. His toes and fingers are exposed. He then slides out from under the coat, only hiding his fingers and toes.

Curtain.

Wild packs of Dogs and Cats

There is a pack of dogs on stage. There is a pack of cats on stage.

They might mingle.

Curtain.

Microphones Perform Without an Audience

A man is on stage, facing the back of the stage. He has a microphone and is wearing blue briefs. He keeps asking the audience to leave over and over. He stops when everyone has left the performance space.

Curtain.

The Fine Line Between Arsonist and Pyromaniac

She imagines a house on fire. She watches it burn while smoking a cigarette and picking her nails.

She leaves her chipped nail polish on stage.

Curtain.

Post-war Trauma and Shellshock

A woman carries a turtle shell on stage. She walks off. Another man is on stage wearing Aviator goggles and a used thong. He tries to crawl inside of the shell. He continues until everyone has left.

Curtain.

Jaywalking or Haphazard Street Crossing or Something Else

I man wearing an animal costume is on stage. He runs outside and into the street. He zig-zags through traffic. His tail has to be run over. He continues until he is exhausted, or until he is hit.

If he is hit, he imagines it never happened; if he survives, everyone else imagines it never happened.

Curtain.

We Can't Stop Her

There is a man with his briefs around his ankles; he is facing the audience. There is also a woman with her panties beside her on the stage, but she is still wearing her bra. She asks the man to twerk. He says no. She asks him again.

Curtain.

Sexual Relations
(Political in Nature)

There is a radio and a bottle of lube on a table. A woman wearing nothing but a fur vest climbs on the table. She turns on talk radio and starts rubbing the lube into the fur. She continues until the bottle is empty and the radio becomes nonsense.

Curtain.

Spit Ends

On the left side of the stage, there is an older man. He has a lip full of chew. Instead of spitting, he swallows it, and then verbally shares a mistake he made as a kid. He repeats this until he pukes. Then he shotguns a beer and smashes the can against his forehead. He walks off stage. The smashed can lies on the stage floor under a spot light.

Curtain.

Glitzy Glamorous Fragments

There is a fan on stage. Glitter is poured out in front of the fan and covers the audience. They never get the glitter off their bodies.

Curtain.

Waiting for the Humans to Become Again

There is a table on stage. There are three chairs. One is turned on its side. There is a missing floorboard. No one is on stage.

Curtain.

Buck Naked

The performers are on stage. They are wearing buck heads. They are hollow, but still have the antlers. They are not wearing anything else, but this only matters semantically. They wait until all the cars have left the parking lot.

Curtain.

The Red Room

She is seated in front of a red screen. There is a cassette player beside her. She hits play. She says she will see you again in 25 years, but she is actually silent. The cassette does the talking.

Curtain.

Edible Complexion

There is a mother on stage. She rubs strawberry jelly all over her face. Her son comes and licks it all off. She thinks about the death of her husband.

Curtain.

KNIGHTMARE/PHANTASY

(SCENES & OBJECTS)

A maple syrup covered pair of briefs

A snake skin inside a llama

A road through the creamy discharge

A thought inside a flowery phallus

A bird eating sweat-stained blazers

A reminder printed on nail clippings

A spanking

A soft whisper on yr toes

A real deal radio razor

A banana peel soaked in diesel

A fear made out of dried carrots

A chopstick for yr rectum

A cold vagina

A sheet of paper painted gold

A buoyant rusty needle

A clearly marked landfill

A hope smashed with a librarian's forehead

A wicker basket covered in vomit

A liar in a bottle of cold salsa

A night without licking a saggy neck skin

A meaningful letter flushed down the drain

A nude beach covered in glitter

A silent treatment inside an igloo

A water balloon split with a scalpel

A ceiling tile covered in piss

A drone in all the urethras

A ghost beside the used condoms

A power line made out of clown drool

A reference beneath the sweat drips

A coma within the lie detector

A walter white with transparent nipples

A kangaroo court with all the bells and whistles

A blowtorch and a sasquatch

A floorboard painted with semen

A sidewalk split with sandpaper

A lower thigh covered in nylon

A spill on abandoned lip balm

A white sock in a pool of cottage cheese

A secret split with a chainsaw

A kite covered in blank checks

A dead body in a room of confetti

A dick soaked in lip balm

A hangover and a silk scarf

A killer wearing blurred pants

A blue hat filled with liquid soap

A dry blanket and a nude sculpture

A gym rat and a test-tube waiting

A snapshot of the cream filling

A light bulb inside a dildo

A quiz based on liver

A corner cluttered

A bill and some snuff

A glitch in a cluster

A bloodhound in a body mitten

A word repeated

A thought and a meaningless

A photo of the brown bush

A lingering feeling covered in misinformation

A chalkboard and a scorpion

A whisper beneath boxes

A bowling ball in overalls

A tampon beside a glass of milk

A beaver with a wedding planner

A sound wave blurring chalk lines

A boxer quoting sartre

A camera in a hot tub

A shin guard glued to light post

A flight attendant and a ferret

A cobra beneath the ceiling fan

A line towards death

A visor and tinted underwear

A liver in a body

A smoking jacket with a pocketknife

A stirring in a hot tub

A becoming in deleuze

A lamp with erotic intentions

A doorway and a paintbrush

A whisper and a salmon

A distance covered in sewage

A symbol in yr everything

!mposs!ble
performancez

gallery show 4 free

 installation one: Send all yr sexts to (xxx) xxx-xxxx
 installation two: Paintings of all sexts received.

ACT ONE

live inside
a computer

ACT TWO

life is
buffering

ACT THREE

life is
buffering

ACT FOUR

life is
pixelated

ACT FIVE

life is buffering

etc.

ACTS 1-3

four walls
one body directly across the table
one body slightly to the left of the first
two bodies slightly to the right of the first
slightly to the right and slightly behind the second of the two
slightly to the right of the first is another body
slightly in front of and to the right of the body that is slightly to
the right and slightly behind the second of the two slightly to the
right of the first is another four bodies
slightly to the right and slightly behind the fourth body from the
last line are two more bodies
one body to the right and slightly in front is one body
four bodies to the right and one more is missing
one body sitting by the wall to the right
slightly behind and to the right are two more bodies
one body to the left

ACT ONE

Inhale.

ACT TWO

Exhale.

ACT THREE

Repeat.

ACT ONE

Climb the rope (or stairs) with neon lights dangling

ACT TWO

Drop the lights

ACT THREE

Let them explode on the concrete

Video tape it all

ACT ONE. Deny

ACT TWO. Denial

ACT THREE. Denihilism

ACT ONE

There are two bulbs & the artist. The artist stands between w/ a cement block at his feet. The walls are within the shot. The artist waits patiently. The artist is wearing a black jacket, black shirt, and black pants. The artist is wearing black shoes.

ACT TWO

The artist picks up the block, steadies the block on one arm & slowly extends over the bulb on the right side of the screen. The artist drops the cement. The bulb shatters.

ACT THREE

The room is only half-lit. The bulb on the left side of the screen is still bright. The artist waits patiently. The artist bends and gathers the cement. The artist lifts & balances the block on one arm. Slowly extends. Loses control & gathers it again. The artist drops the cement. The bulb shatters. Black screen.

ACT 404

The page cannot be found.

ACT two
::This is where the show begins.

> There is no ACT one, and really,
> who gives a shit.

This exhibit demonstrates
the prevalence of sexuality
in the sacred.

/Bodies are always members of both realms.

/Bodies like pure hearts and pleasure parts.
Sacred/Sexual
1. LAST SUPPER / VAMPIRE SCENE
2. WOMAN AT THE WELL / FIRST DATE
3. MARY & JESUS / LOVE EVERLASTING
4. DAVID & BATHSEBA / ROM-COM minus COM
5. SOLOMON & BREASTS / SEXTS

ACT three

GODOT EXPERIENCES DOUBT & absence

MY GODOT WHY HAVE YOU FORSAKEN YRSELF
 WHY HAVE YOU MISTAKEN YRSELF
 WHY HAVE U MADE NAKED YRSELF

 TEMPLE TEARS AND OOZES THE SACRED ON
EVERYTHNG
 SEX TOO / SEX TWO / SEXTS YOU

Act One
>> It is a ballet. Only it is

>> only on the page. The
characters seem too real to ever be acted out.
>> One girl has perfect bones. She
>> can dance on the page with suicidal
>> tendencies.

Act Two

>> ~~She tries to fall in love, but there is no one else there.~~
A man with glasses and an anxious

shake steps on stage.

>> He will always fail her: slowly his arms start to
>> melt, and his head disappears. He wasn't real to begin
>> with.

Act Three

>> The final song starts
>> >> soft and then
>> >> >> blooms into something
sleepless. She falls in love
>> with the stage in the darkness, or so it seems.

>> >> she spins

>> skirt motion

>> her perfect

indigo bones

and love letter

 eyelashes

 who knew she had razor blades?

www.ingramcontent.com/pod-product-compliance
Lightning Source LLC
Chambersburg PA
CBHW020926180526
45163CB00007B/2898